DRAW IT CUTE!

100+ ADORABLE ANIMALS AND AMAZING CREATURES

Heegyum Kim

QUARRY

CONTENTS

INTRODUCTION

I've always loved to draw. Though I work full-time during the day, I draw in the evenings as part of my daily routine. And I have whole weekends to dedicate to drawing! I find inspiration everywhere: in my local surroundings, reading books, watching TV shows, observing people, through conversation with friends, and browsing other artists' works on Instagram.

When I began writing this book, I realized there were many animals and creatures I had never previously tried to draw. In order to understand an animal or a character's physical characteristics, I did some research before I started drawing, and I recommend that you do the same. Research helps me not only to achieve a likeness, but also to imagine a personality.

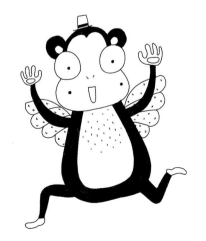

Use this book as a guide and reference to develop your own animals and creatures. On each page, follow along with the step-by-step guide to drawing the basic form. Concentrate on the main geometric shapes that combine to make the figure. Then add identifying features such as ears, arms, or feet. Lastly, fill in the facial attributes that bring the character to life. Some of the pages also include other drawings of various poses and expressions.

Experiment with a variety of pencils and pens to get familiar with how they feel and the kind of marks they make. Most of the drawings here begin with pen or pencil lines and some feature colored pencil for variety.

Remember, the best way to get better at drawing is to draw! Set up a regular practice or find time when you can. I hope this book provides you with loads of fun ways to expand your drawing skills and your imagination.

DRAW AN ALPACA

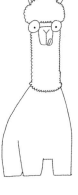 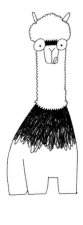 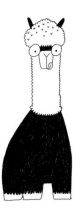

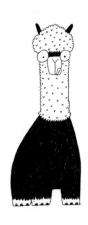 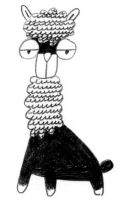 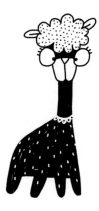

DRAW A FUGU

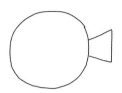 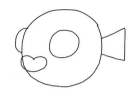 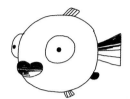

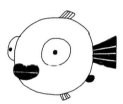 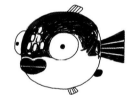 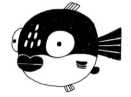

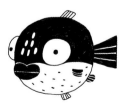

TIP
**Think about how you can
vary the eyes of your character.**
Work on a scrap paper to practice
with different styles. Draw eyes with
lids by adding a horizontal line
and draw a pupil in the lower half.
Use different sized pupils or
eyebrows to show expression.

DRAW A PUFFIN

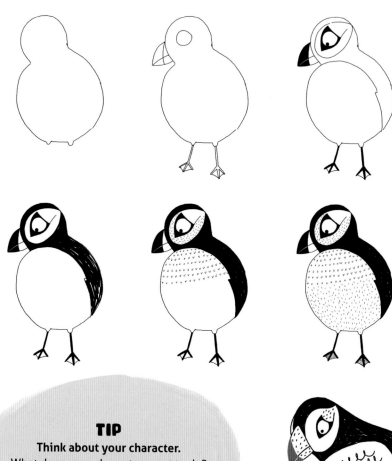

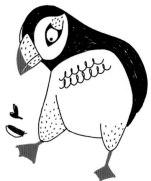

TIP
Think about your character.
What does your character want to do?
What is she thinking about? How is your
character feeling? How are you feeling?
Imagining stories about your animals will
help bring your drawings to life.

DRAW A BEAR

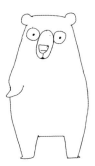

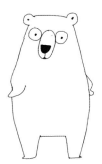

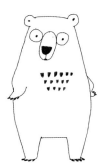

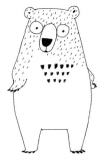

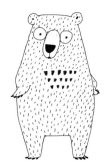

TIP
There are many ways to achieve the look of fur. You can use small notch marks in an all-over pattern or make tighter notch lines in little rows. You can also represent fur by moving your pencil in a repeating loop. Experiment with your own ways to show fur.

DRAW A KIWI BIRD

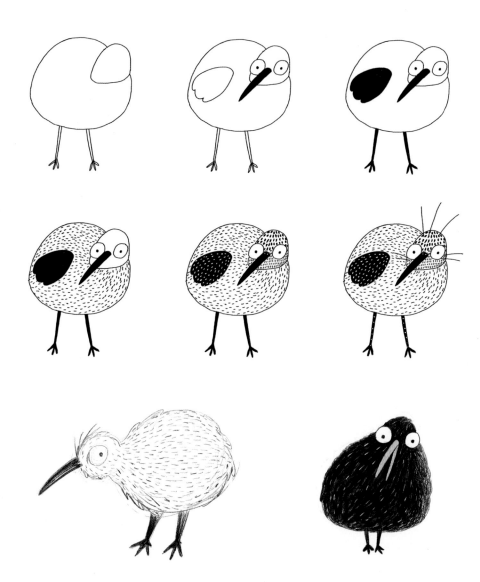

DRAW A KOALA

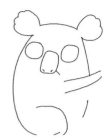

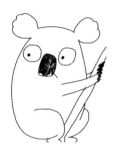
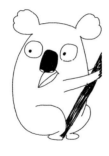
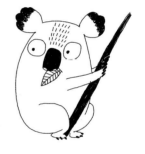

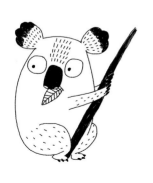
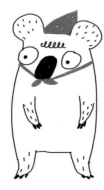
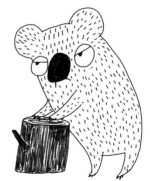

DRAW AN OSTRICH

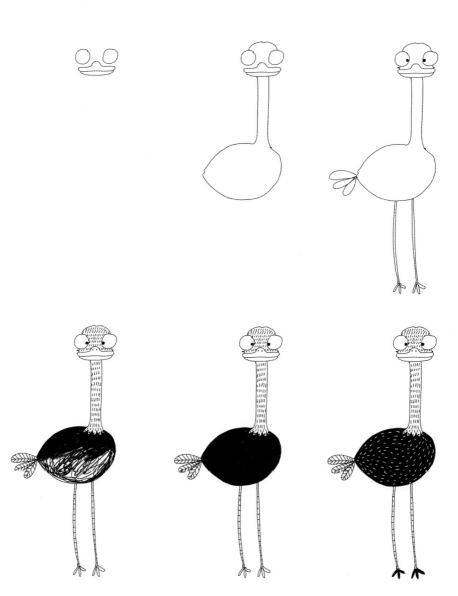

DRAW A PLATYPUS

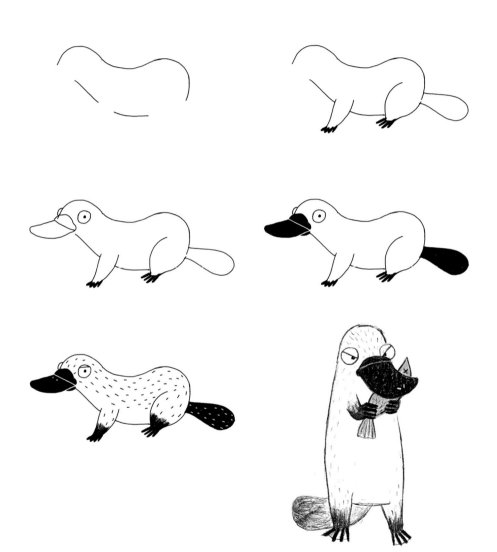

DRAW A CAPYBARA

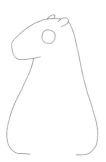 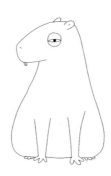 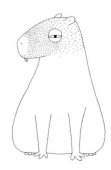

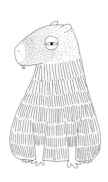 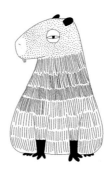 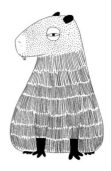

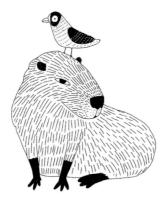 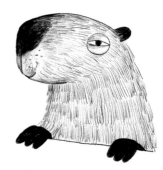

DRAW A CHICKADEE

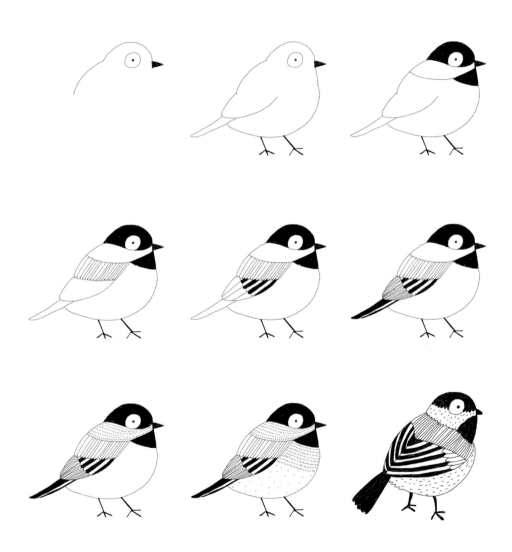

DRAW A GIRAFFE

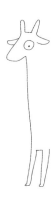

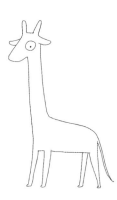

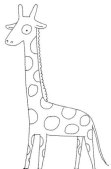

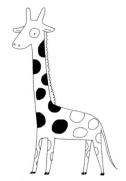

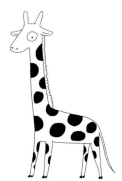

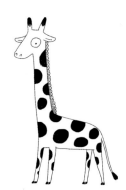

TIP
Exaggerate the anatomy of the animal you are drawing to make it more easily recognizable and to add personality to the drawing. For example, see how the length of the giraffe's neck serves to make it extra cute and silly?

DRAW A KANGAROO

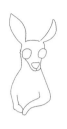
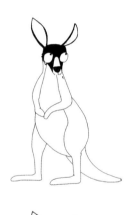
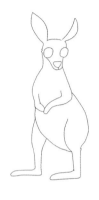
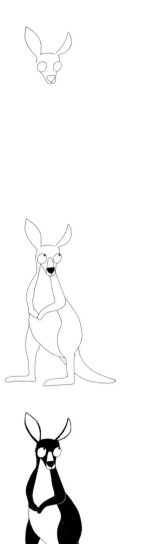
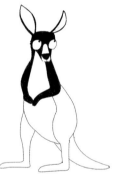
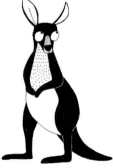
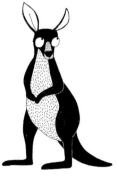

DRAW A MEERKAT

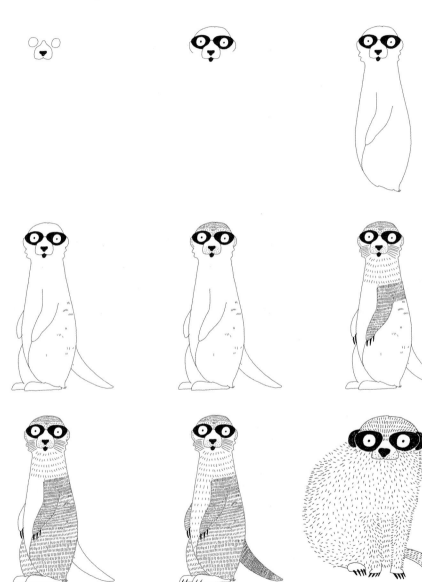

DRAW AN OWL

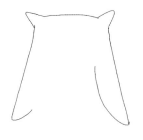 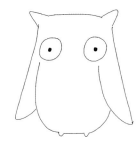 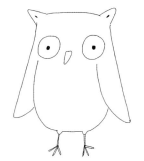

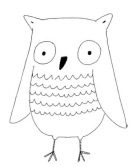 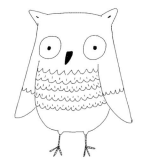 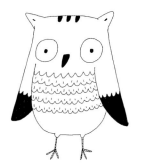

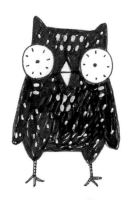

TIP
Scalloped lines work well to evoke the pattern of feathers. They can be attached or separated "U" shapes. Add dots to the center of each scallop for a decorative look.

DRAW A FROG

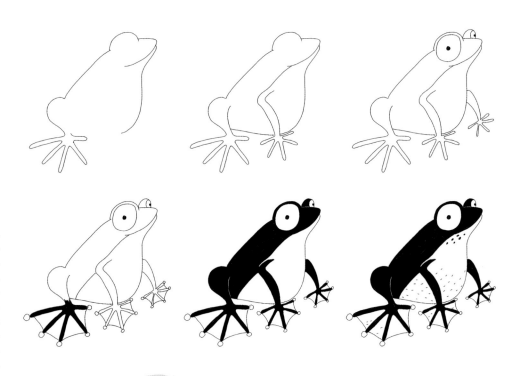

TIP
Reptile skin can be quirky and unusual. Try a mix of different marks to achieve the variation. For this frog, you will see a mix of small hatch marks, some small irregular dots, and some larger filled-in dots.

DRAW AN OTTER

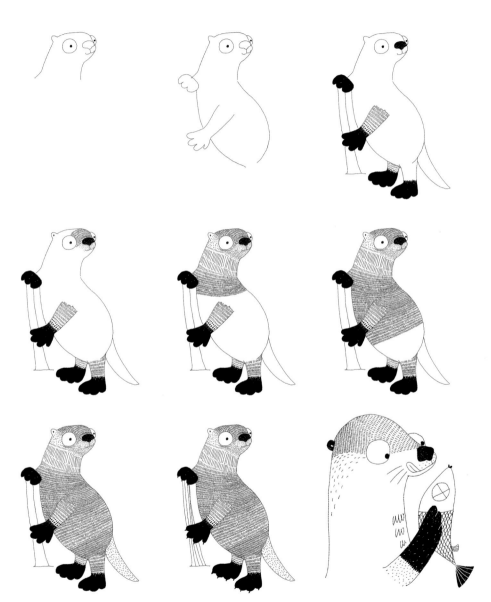

DRAW A PENGUIN

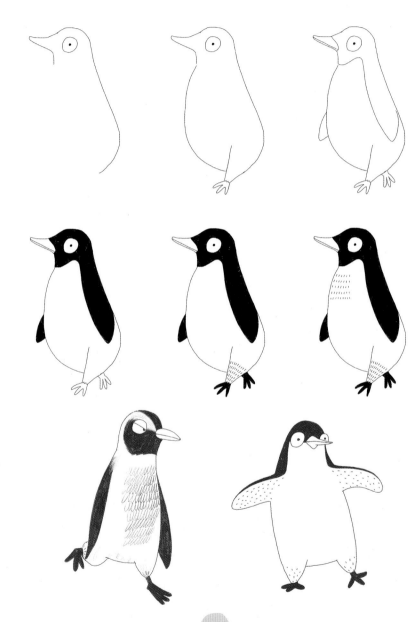

DRAW A RACCOON

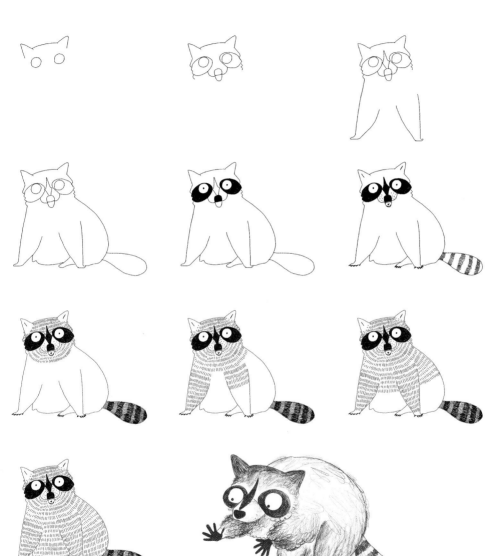

DRAW A TOUCAN

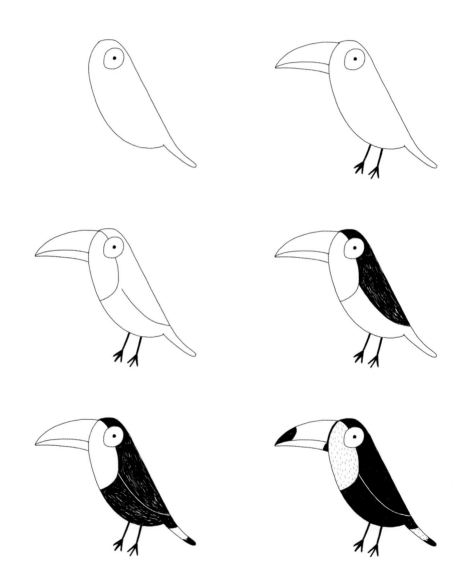

DRAW A WOMBAT

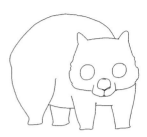

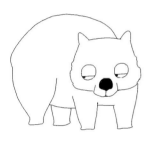
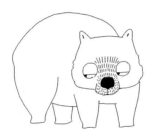
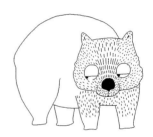

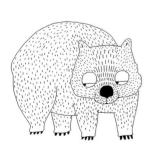
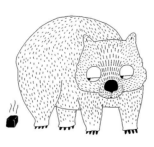

DRAW A SHEEP

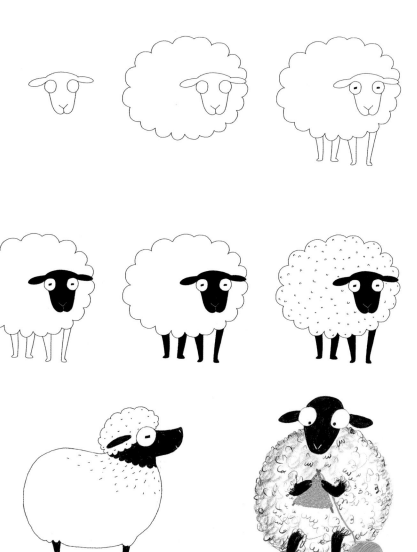

DRAW A CORGI

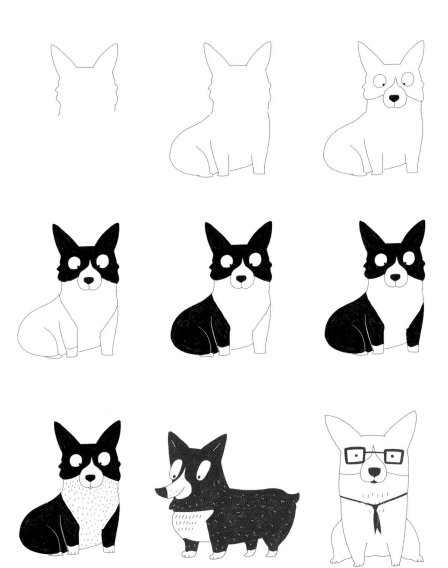

DRAW A HEDGEHOG

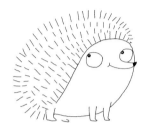

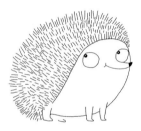

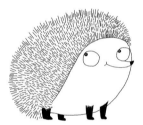

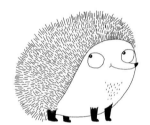

TIP
Try different drawing tools.
While many of the drawings shown in this book are made with a fine- or medium-weight black pen, try using charcoal pencils or conté crayons. Use a blending stump or tortillon to smudge your lines to create different types of texture.

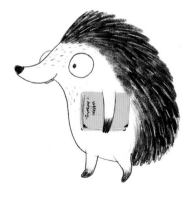

DRAW AN ELEPHANT

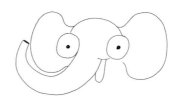

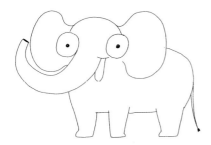
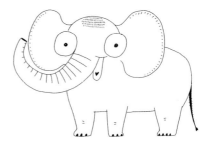

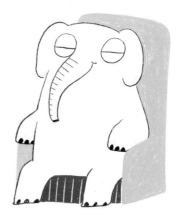

DRAW A CHICKEN

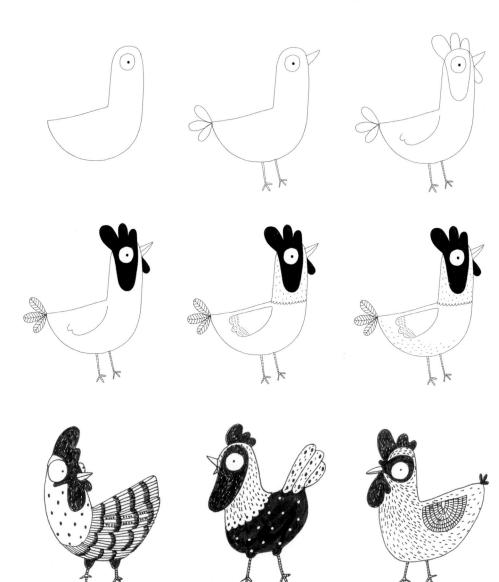

DRAW A RED PANDA

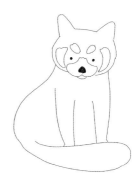

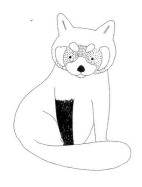
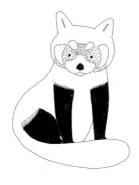
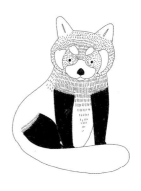

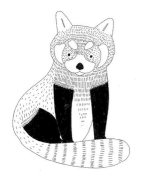
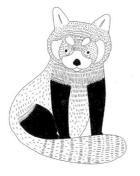
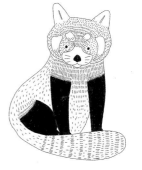

DRAW A LEMUR

 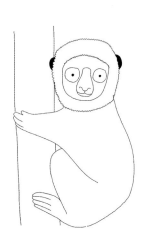 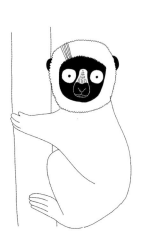

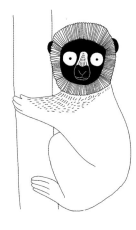 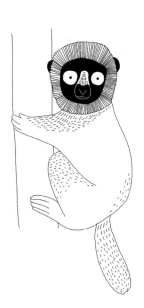 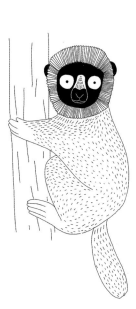

DRAW A PIG

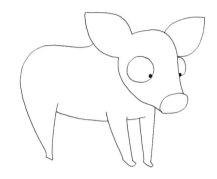

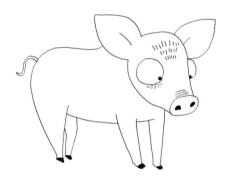

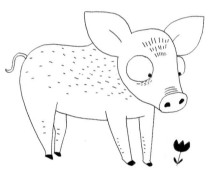

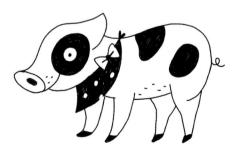

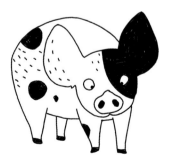

DRAW A RABBIT

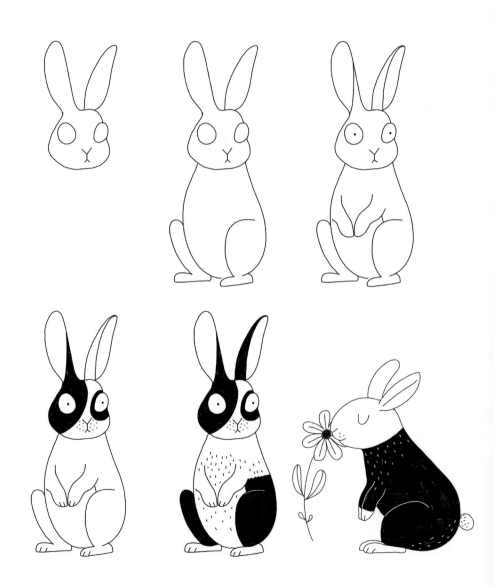

DRAW A MOUSE

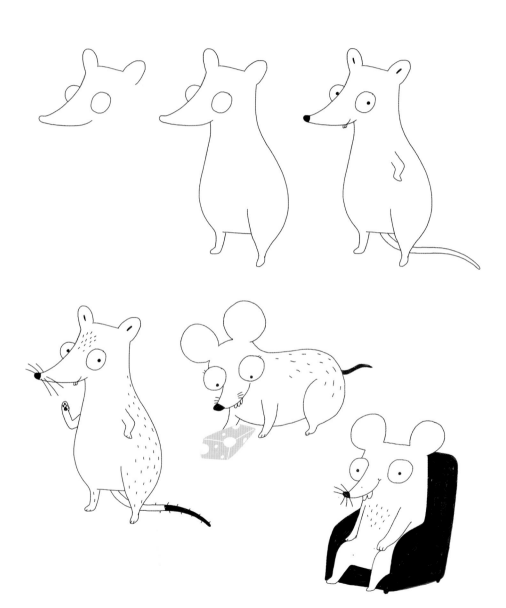

DRAW A DUCK

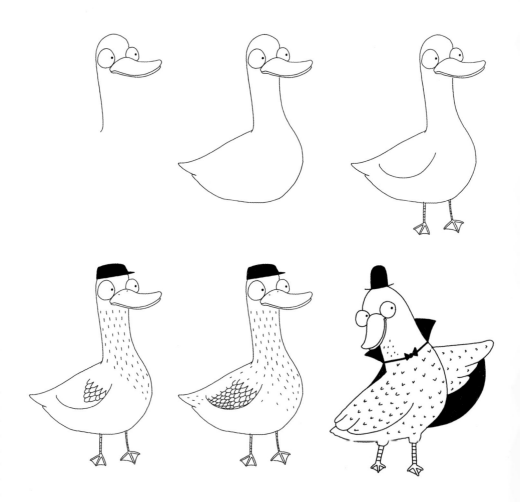

DRAW A TURTLE

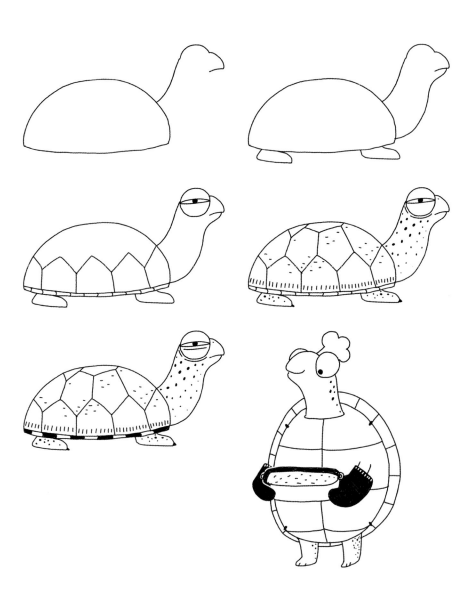

DRAW AN ANGLERFISH

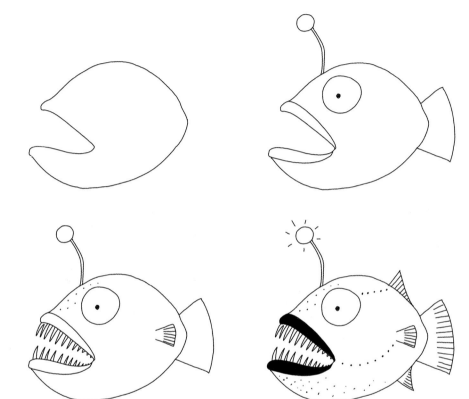

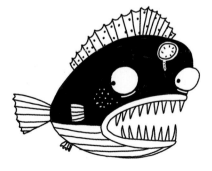

DRAW A PANDA

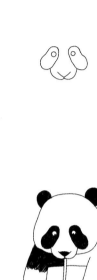
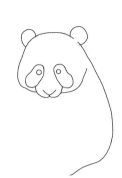
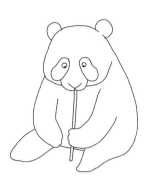

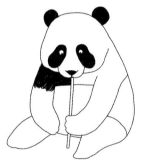
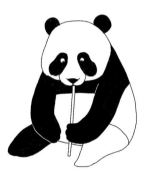
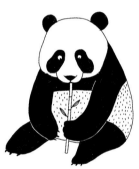

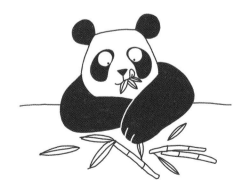
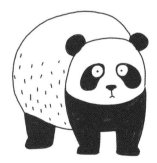

DRAW A SAUSAGE DOG

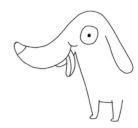

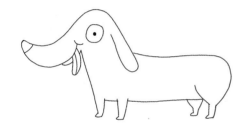

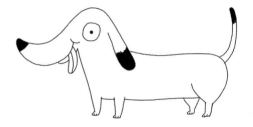

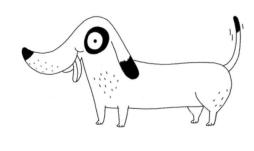

DRAW A GOAT

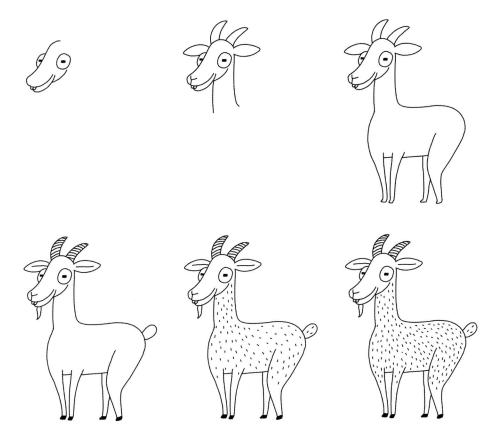

DRAW A SNAIL

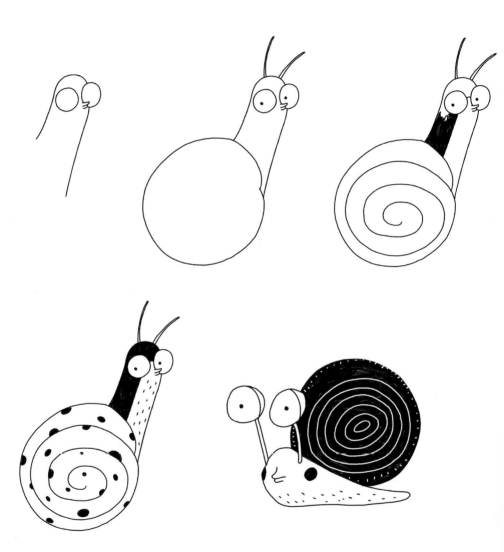

DRAW A WHALE

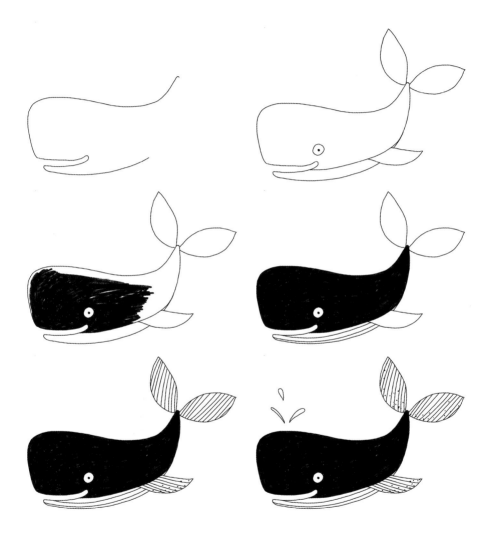

DRAW A HIPPO

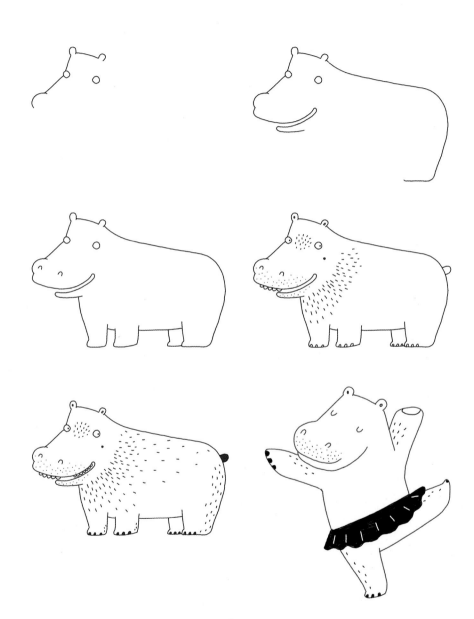

DRAW A SLOTH

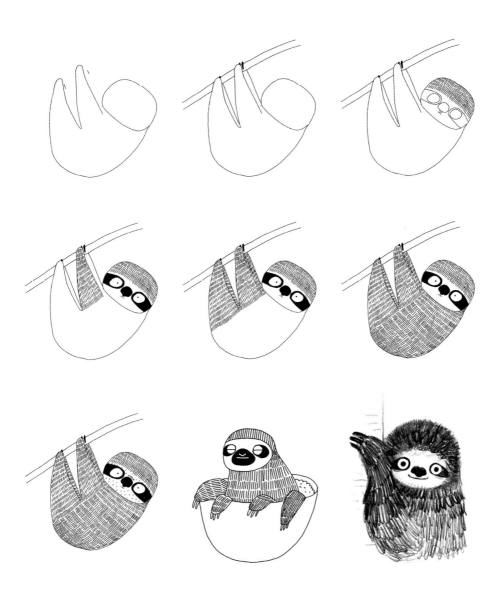

DRAW A MOLE

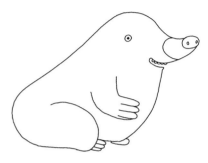

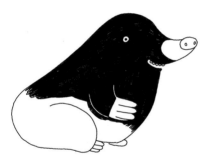
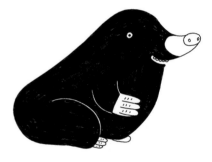

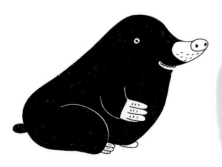

TIP

It is hard, but not impossible, to make a mole look cute. It helps to give him a smile. Smiles are cute. The body is a curvy blob, with especially big hands. The hands and the snout are the uniquely recognizable features.

DRAW A SANDERLING

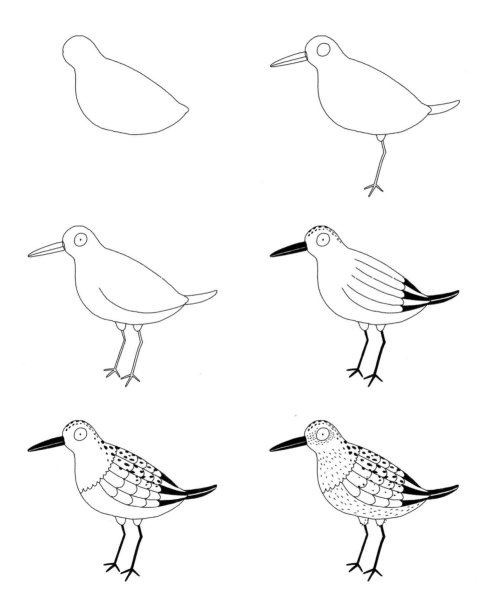

DRAW A TAPIR

DRAW A CAMEL

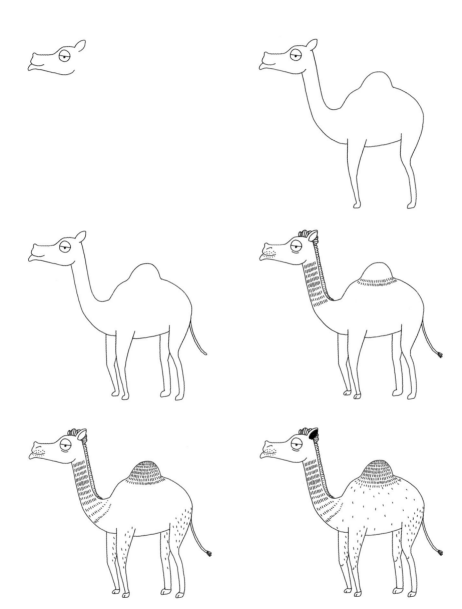

DRAW A SQUIRREL

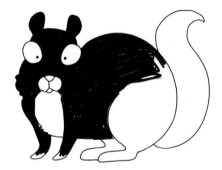

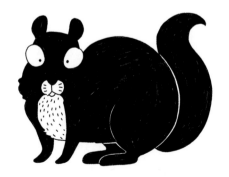

TIP
When there is too much black, use a white paint pen or gel pen to mark over the top and break up the solid areas with white lines.

DRAW A SKUNK

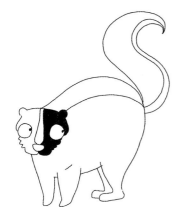

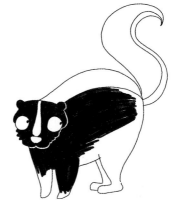

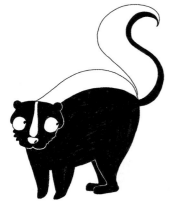

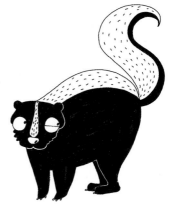

DRAW A GROUNDHOG

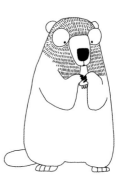

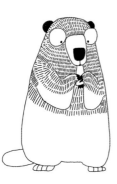
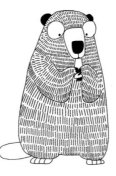
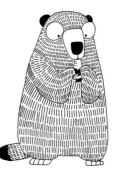

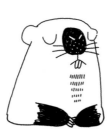
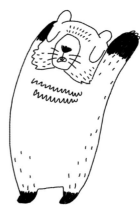

DRAW A FOX

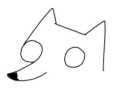

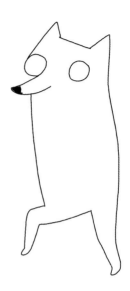

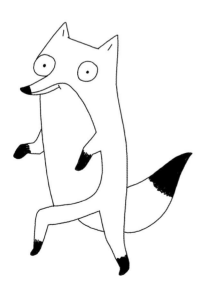

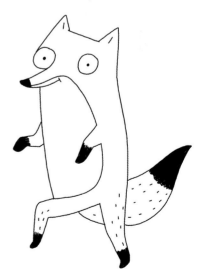

DRAW AN AARDVARK

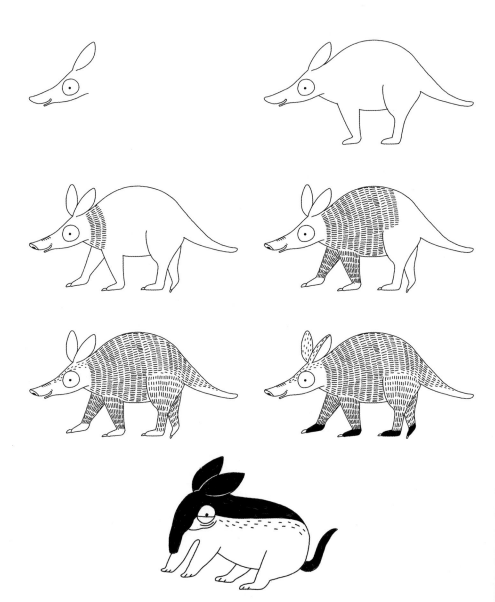

DRAW A BEE

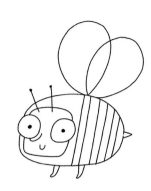
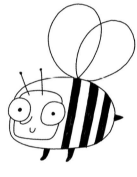
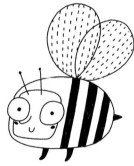
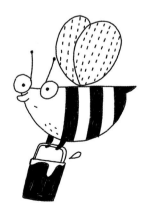
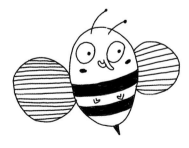

DRAW A DEER

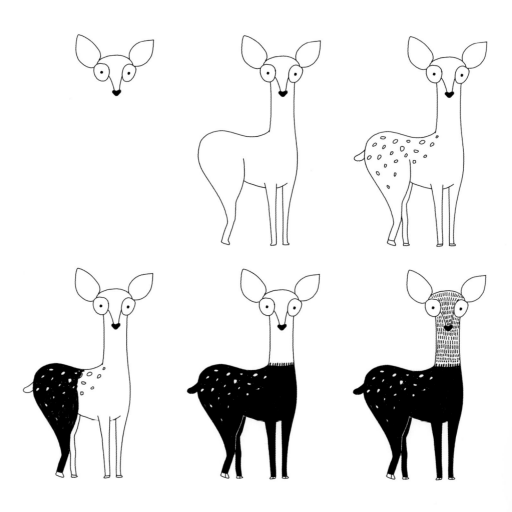

DRAW A NARWHAL

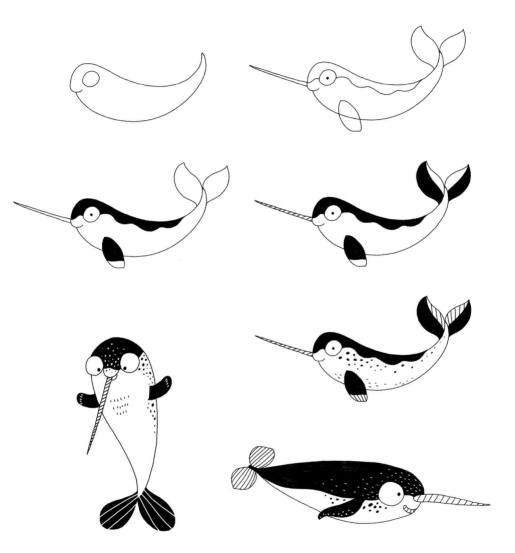

DRAW A ROBIN

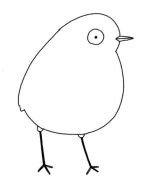

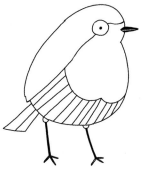

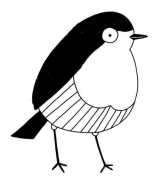

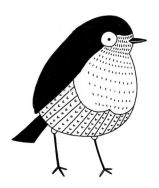

TIP

There are many interesting ways to approach the patterns on a bird's body. Create your marks parallel to the direction of the feathers. Even if you aren't drawing each one, you can draw a few feather shapes and imply others with simple lines.

DRAW AN ARMADILLO

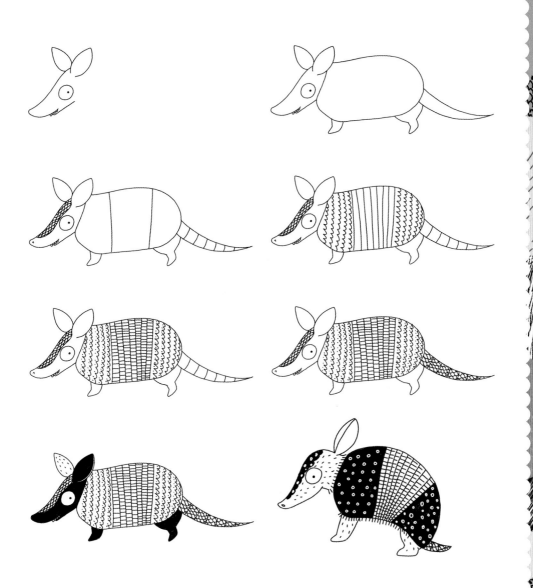

DRAW AN OCTOPUS

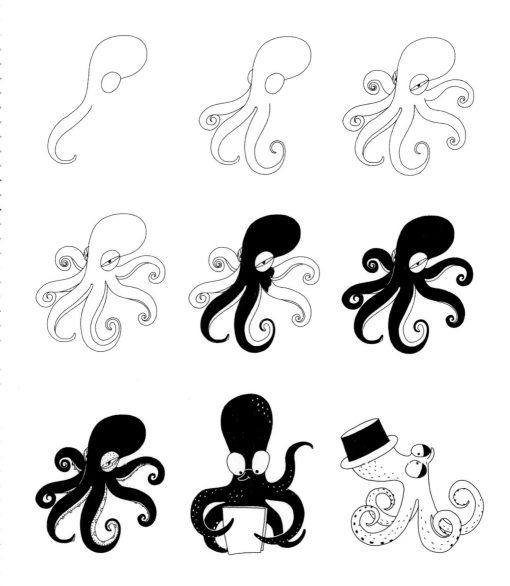

DRAW A DONKEY

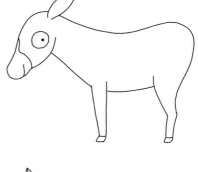

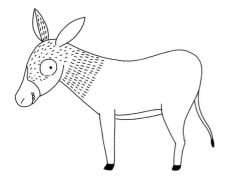

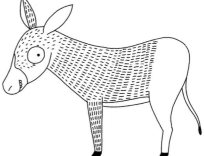

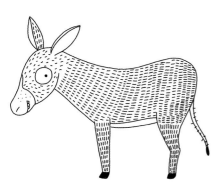

TIP
Think about color contrast as you develop your animals—for example, where to fill with solid color and where to fill with pattern. Using both elements will give your character depth.

DRAW A SEAL

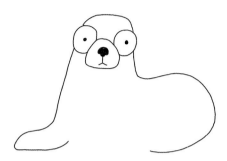

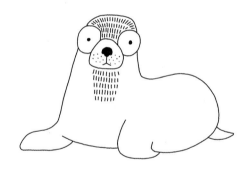

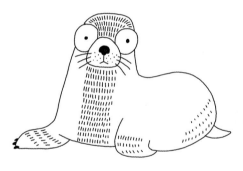

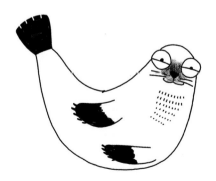

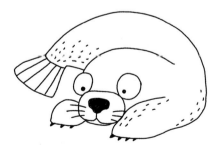

DRAW A WEASEL

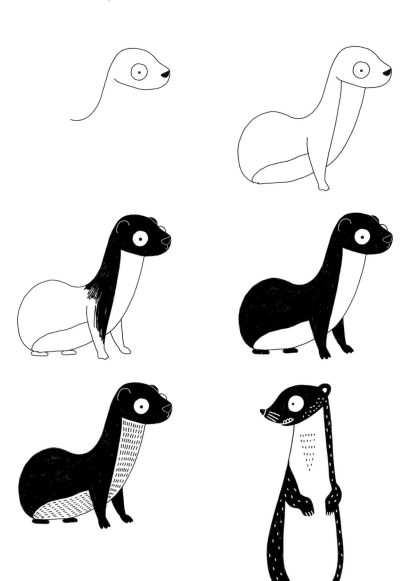

DRAW A CROCODILE

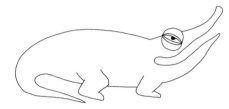

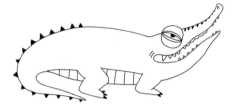
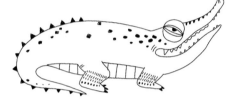

DRAW A JAVA SPARROW

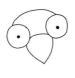
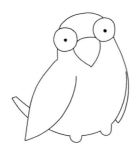
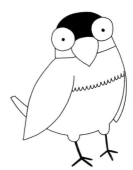

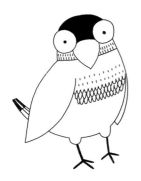
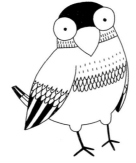
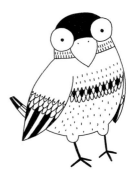

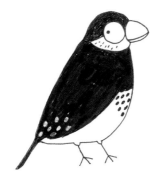
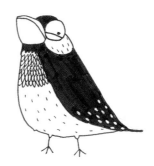

DRAW A CAT

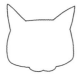
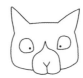
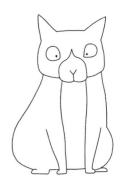

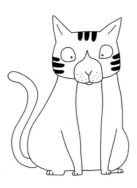
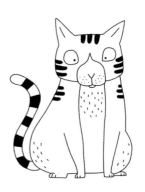

DRAW A CHINCHILLA

 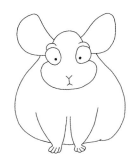 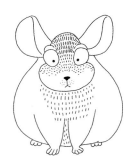

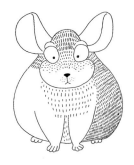 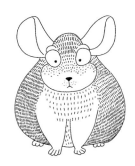 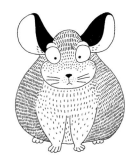

 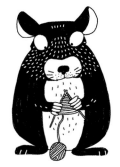

DRAW A DRAGON

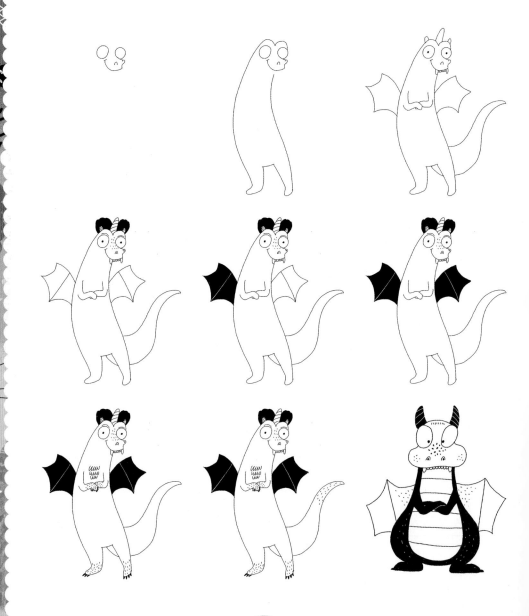

DRAW A UNICORN

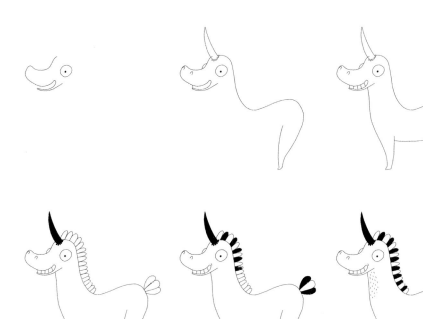

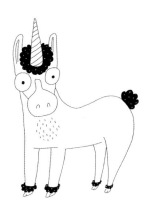

TIP
Sometimes, starting with the face will help guide the direction of your drawing. Since this unicorn was wide-eyed and smiling, I used a playful scallop design for its mane and perky tail. Think about how the facial expression can be reinforced with other elements of your drawing.

DRAW A DODO

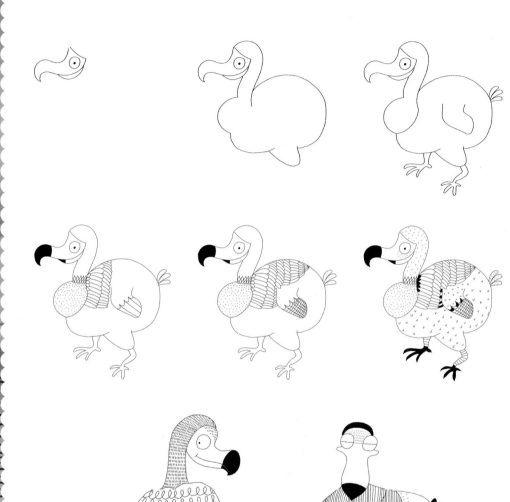

DRAW A MERMAID

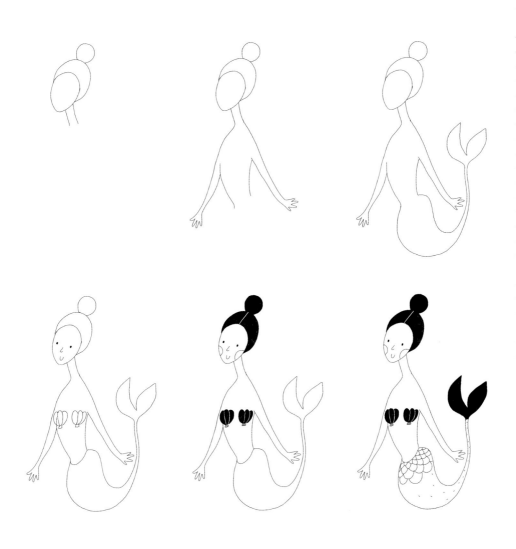

DRAW A GNOME

 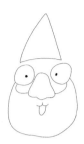 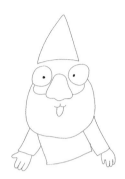

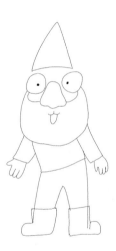 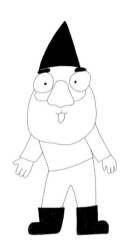 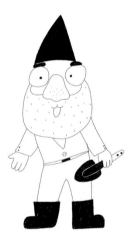

TIP

After you complete a simple line drawing, fill in select areas with solid black to create depth. The black hat, brows, and boots helped to initially frame the figure, and adding a small black buckle and trowel provided balance in the final version.

DRAW A MANDRAKE

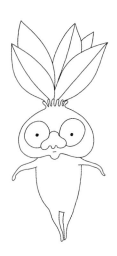

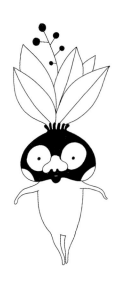

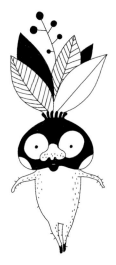

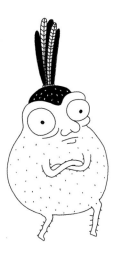

DRAW AN ANGEL

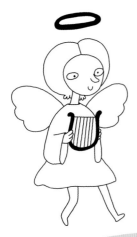 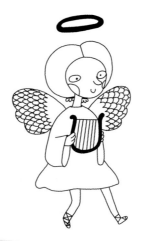 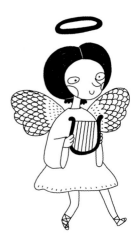

TIP

Pay attention to small details as you finish your sketch. The feather pattern in the wings adds nice texture to this drawing. The repetitive lines in the harp mimic the density of the feathers. The dots on the wing interior are echoed along the edge of the skirt, creating a nice harmony.

DRAW A BIGFOOT

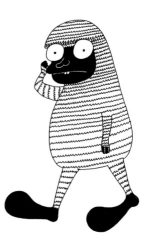

DRAW A BOOGEY MAN

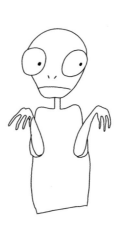

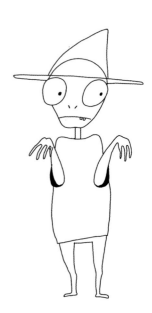

DRAW A BROWNIE

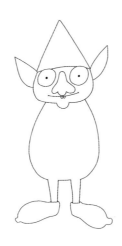
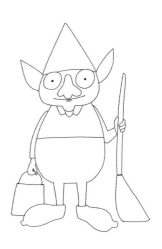

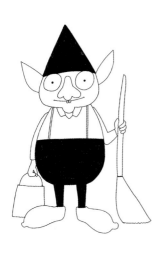
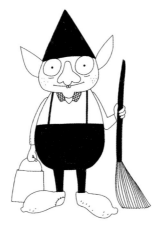
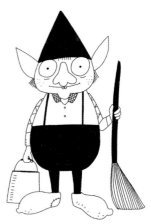

DRAW A CENTAUR

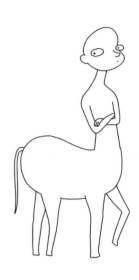
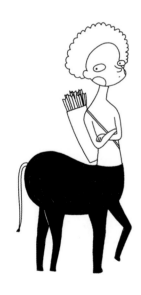
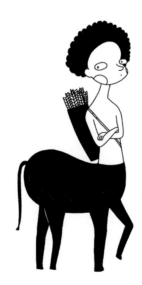
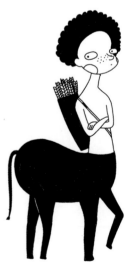

DRAW A CHIMERA

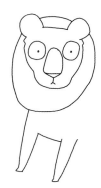

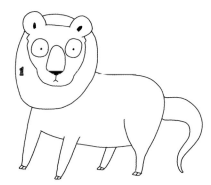

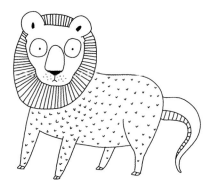

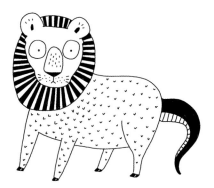

TIP

In Greek mythology, a Chimera is a hybrid monster with a lion's head, a goat's body, and a serpent's tail. How many ways can you re-imagine this creature by blending characteristics of three different animals?

DRAW A CYCLOPS

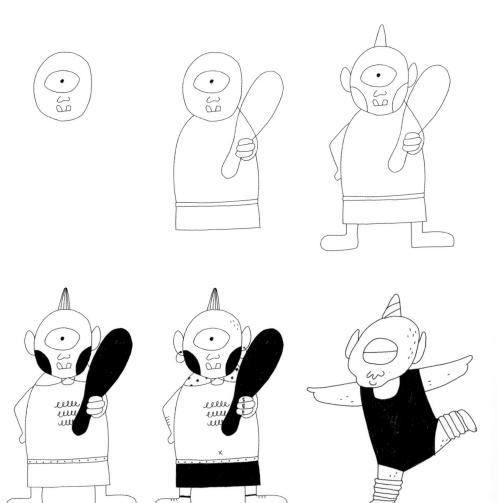

DRAW A DEMON

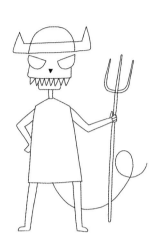
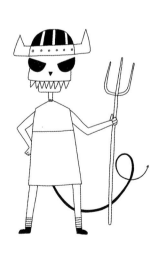
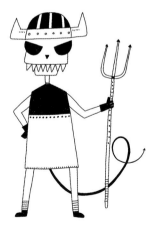
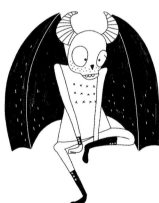

DRAW A DWARF

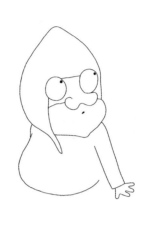
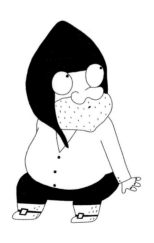
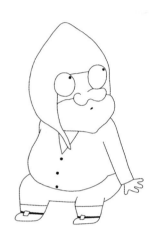
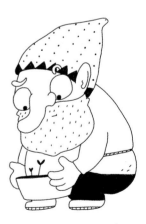

DRAW AN ELF

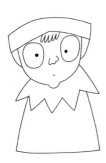
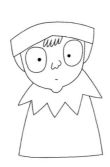
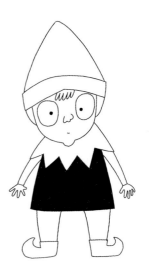
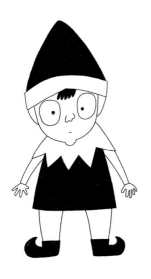
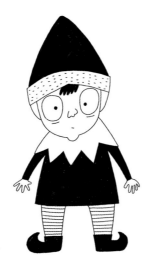
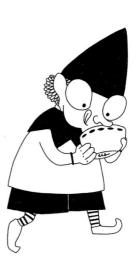

DRAW A FAIRY

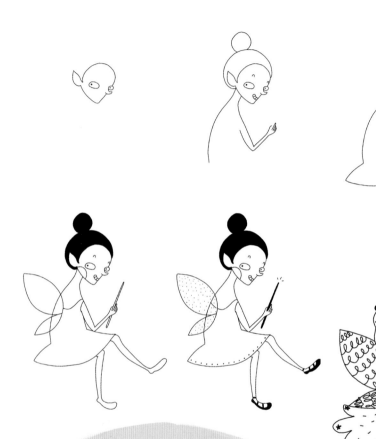

TIP
Even though this fairy is the same size as the other creatures in this book, she still feels diminutive. Use a light hand and delicate shapes and patterns to create your fairy. If you use a dark heavy line, how does your fairy change?

DRAW A FAUN

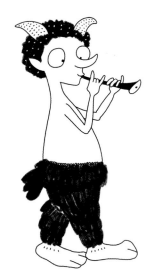

DRAW FRANKENSTEIN

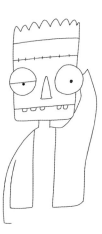
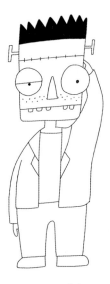

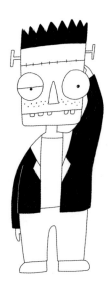
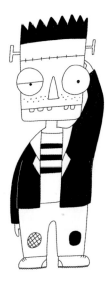
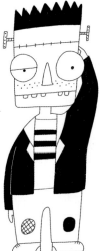

DRAW A GARGOYLE

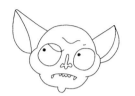

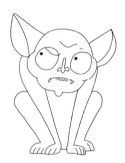

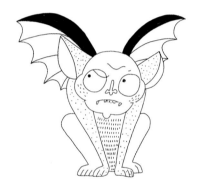

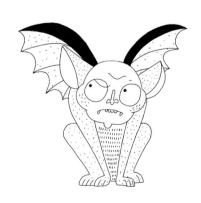

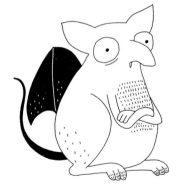

DRAW A GHOST

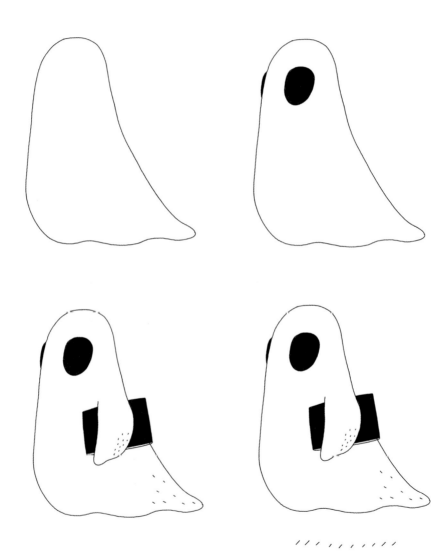

DRAW A GHOUL

 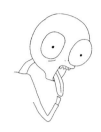 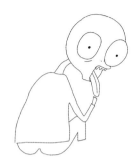

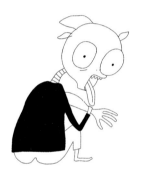 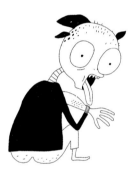 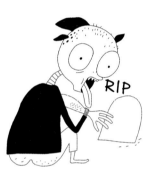

RIP

DRAW A GOBLIN

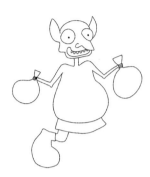

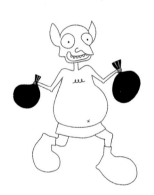

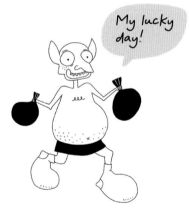

My lucky day!

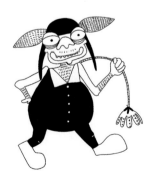

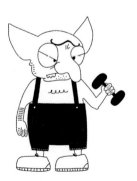

DRAW A GRIFFIN

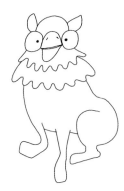

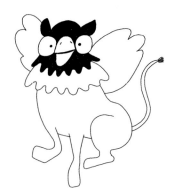

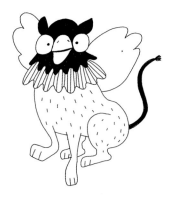

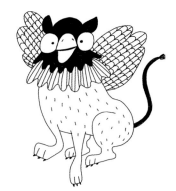

DRAW A HIPPOGRIFF

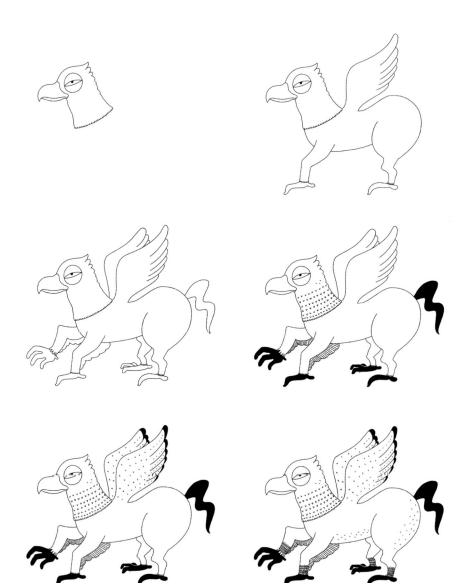

DRAW A HOBBIT

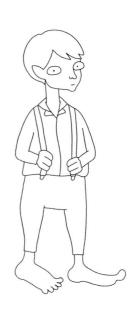
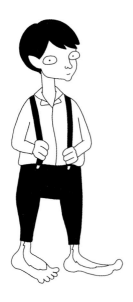
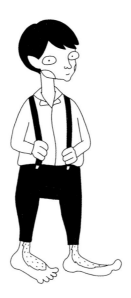
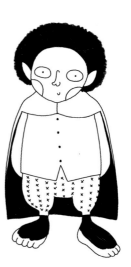

DRAW AN IMP

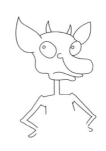
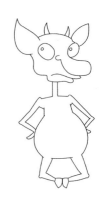

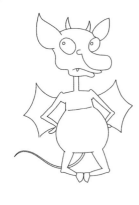
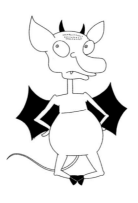
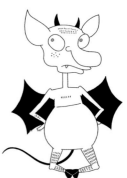

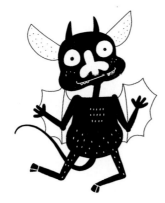
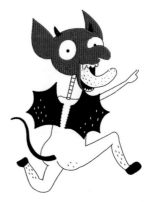

DRAW A KRAKEN

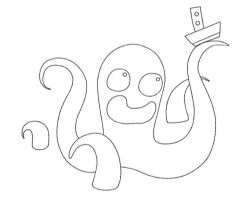

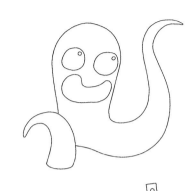

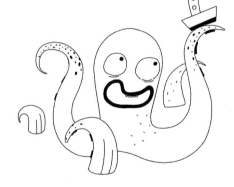

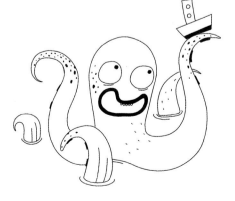

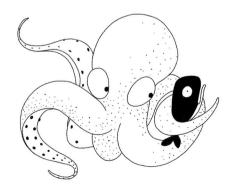

DRAW A LEPRECHAUN

 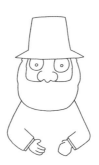 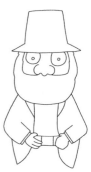

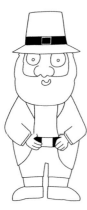 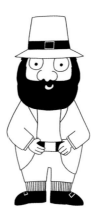

DRAW MEDUSA

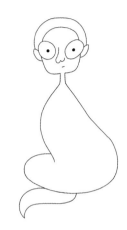
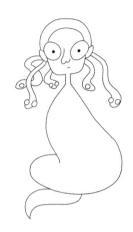
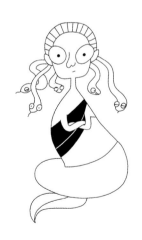
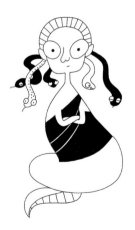
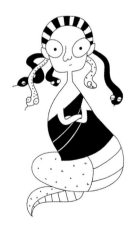

DRAW A MINOTAUR

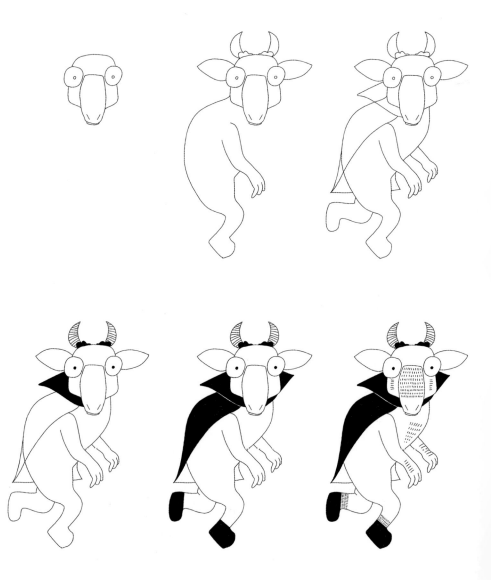

DRAW NESSIE

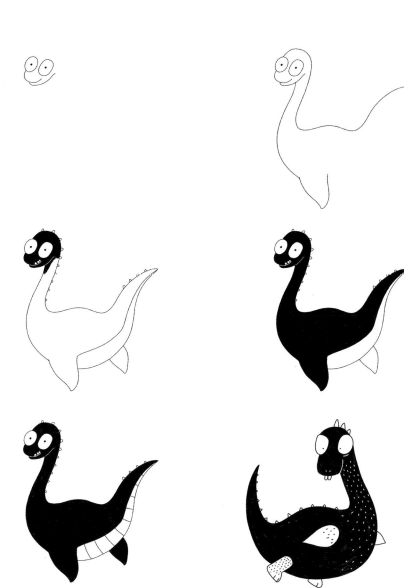

DRAW AN OGRE

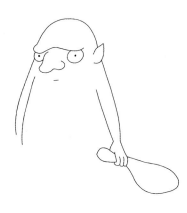

DRAW AN ORC

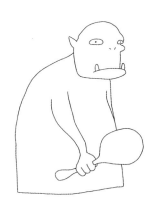
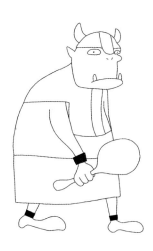
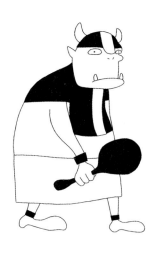
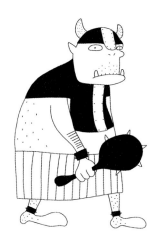
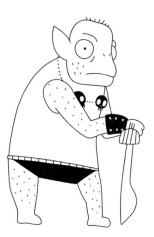

DRAW A PEGASUS

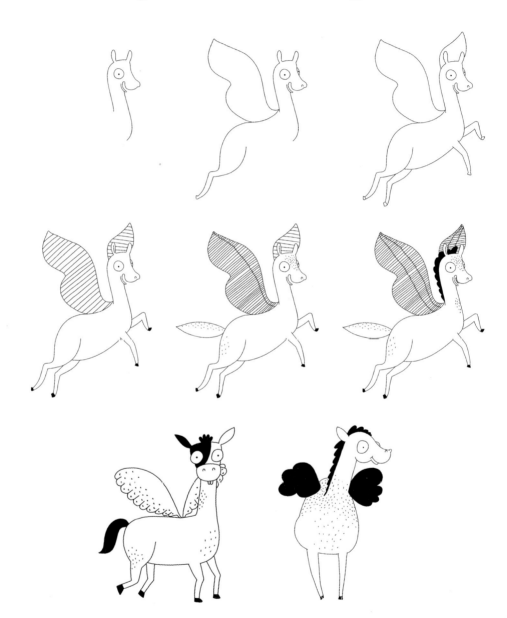

DRAW A PHOENIX

TIP

A phoenix is a regenerative bird, rising from the ashes. For your phoenix, experiment with different lines and methods to signify feathers. Repeat your marks in different ways to fill out the shapes.

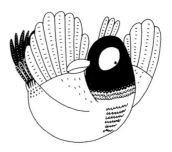

DRAW RUMPELSTILTSKIN

 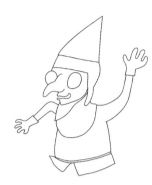 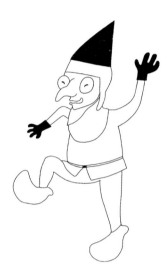

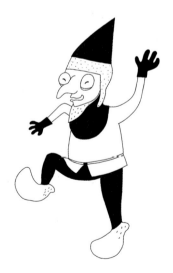 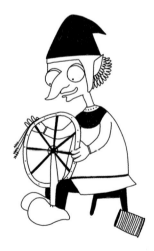

DRAW A SALAMANDER

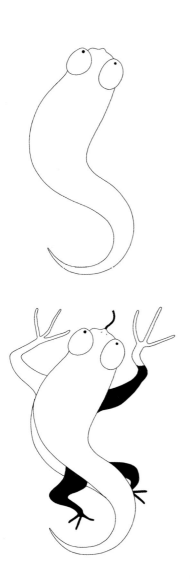
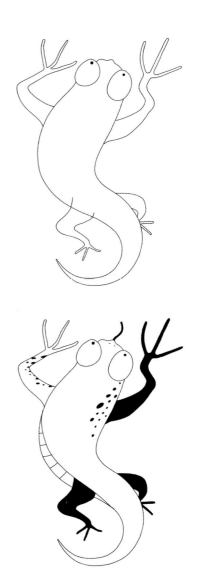

DRAW A SEA HORSE

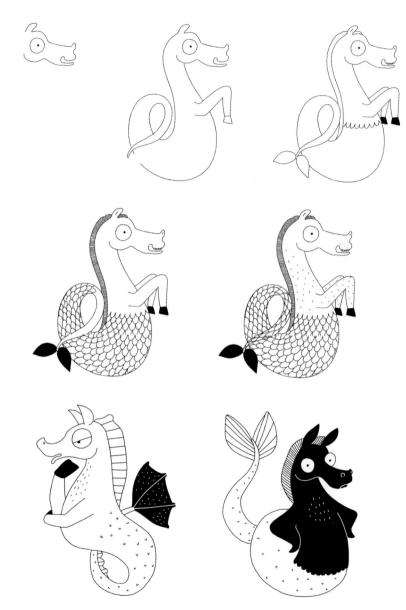

DRAW A SIREN

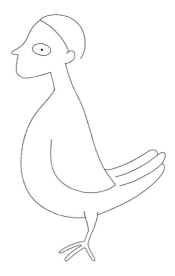

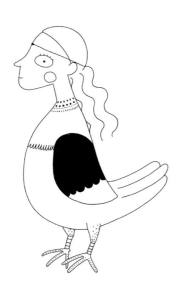

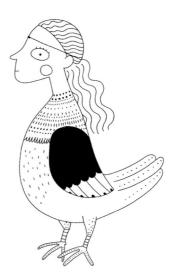

DRAW A SPHINX

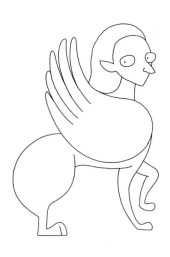

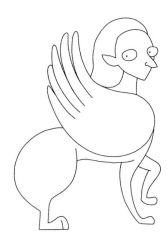

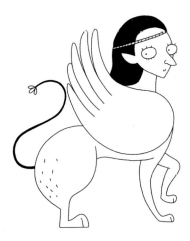

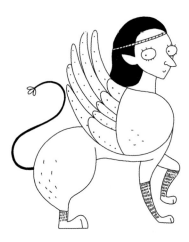

DRAW A TENGU

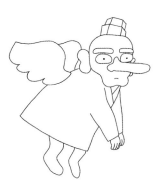

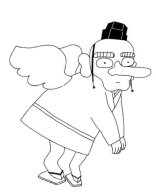

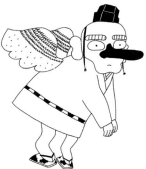

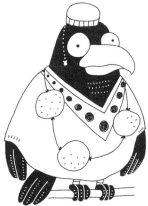

TIP
A Tengu is a legendary, supernatural creature found in Japanese folklore. Over the years, they have been portrayed in many ways, but often with human and avian characteristics. You can find many visual references for this character online. Make this version all your own!

DRAW A TROLL

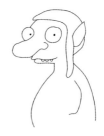

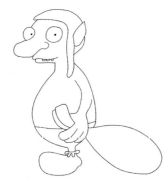

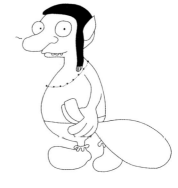

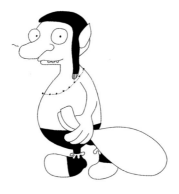

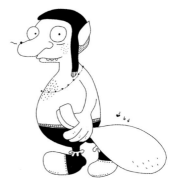

DRAW A VAMPIRE

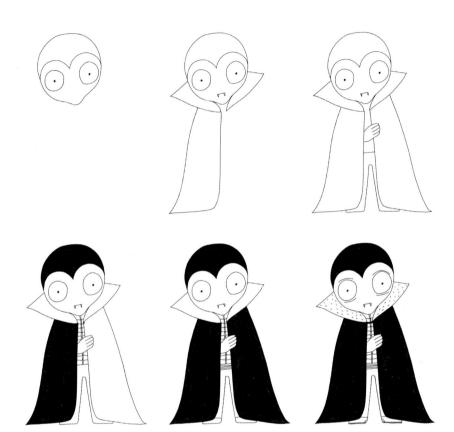

TIP
Vampires comes in all shapes and sizes.
Focus on your vampire's eyes: How can
you make them look vacant and frightening?
Or timid and innocent? Experiment
with the lines around the eyes to
change the expression.

DRAW A WEREWOLF

 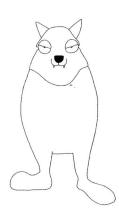 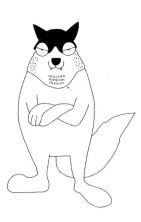

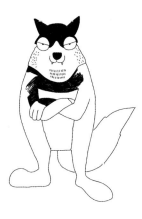 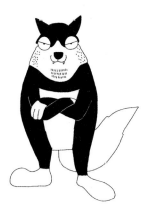 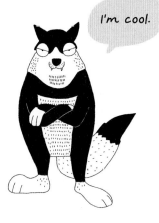

I'm cool.

DRAW A YALE

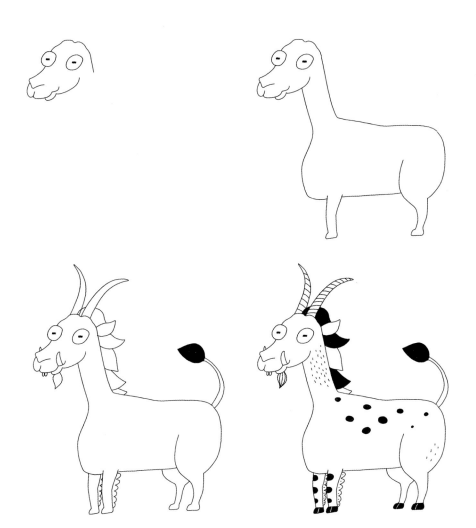

DRAW A YETI

I don't get it.

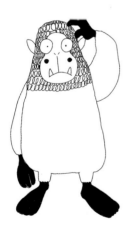
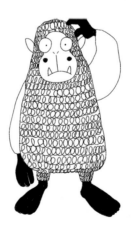
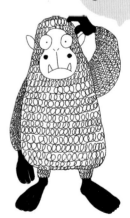

DRAW A ZOMBIE

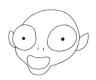
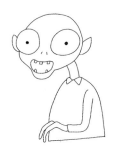
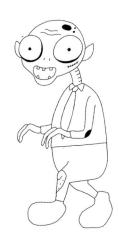
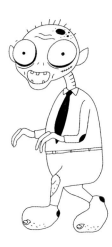
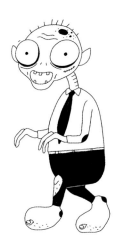
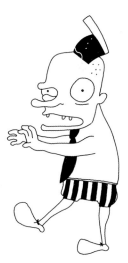

DRAW A FLOWER FAIRY

 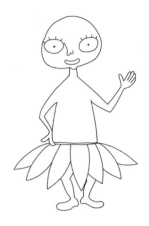

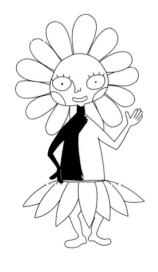 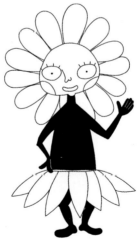 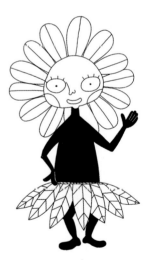

DRAW A DOKKAEBI

DRAW AN ENCHANTED ELEPHANT

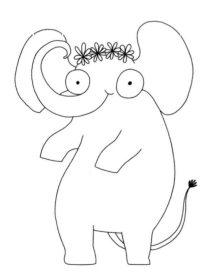

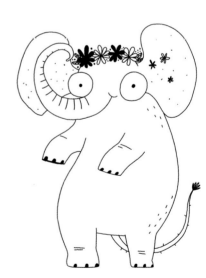

DRAW A FOREST FAIRY

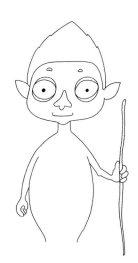
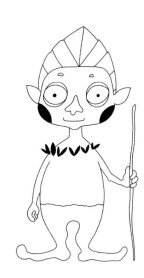
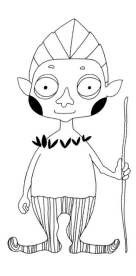
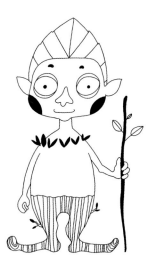
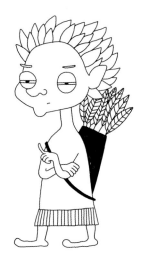

DRAW A GENIE

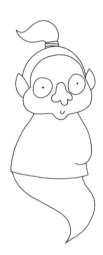
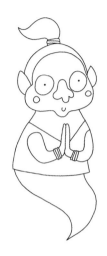

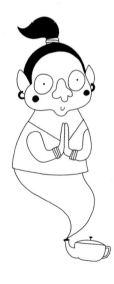
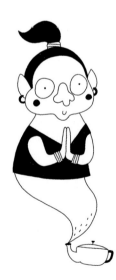
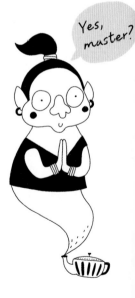

Yes, master?

DRAW A KUMIHO

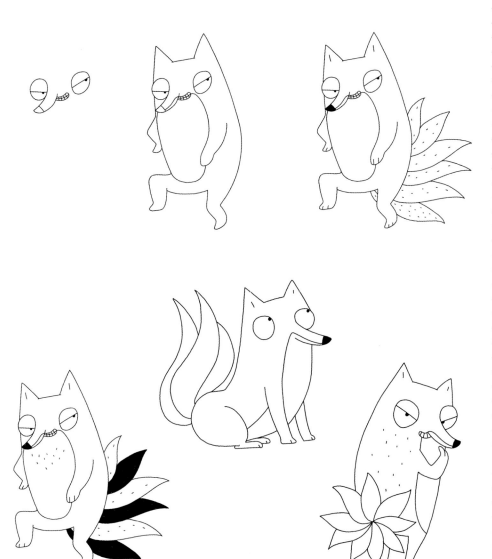

DRAW A GRUMPY WIZARD

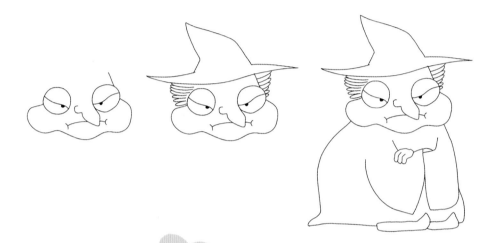

I hate it.

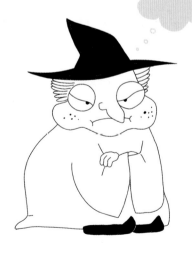

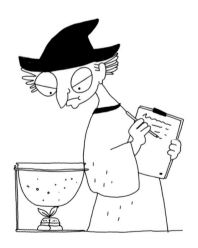

DRAW A FLYING MONKEY

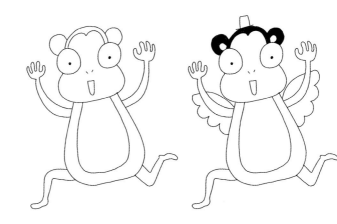
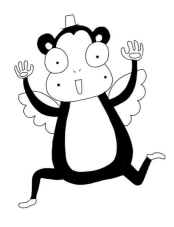
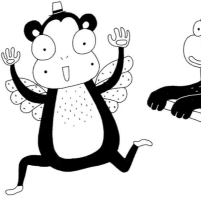

DRAW A MUMMY

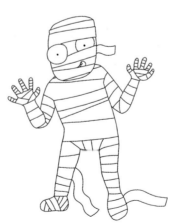

Suprise!

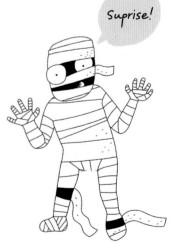

DRAW A HOUSE ELF

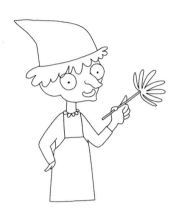

Cleaning is
my favorite!

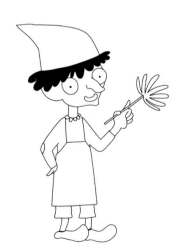
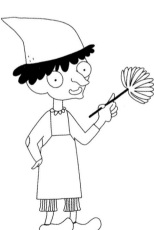
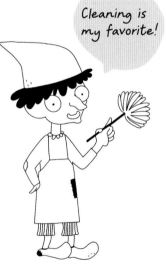

DRAW THE MAJESTIC CORGI

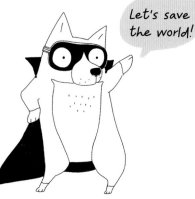

Let's save the world!

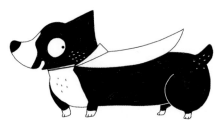

DRAW A MERMAN

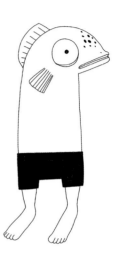
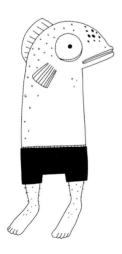
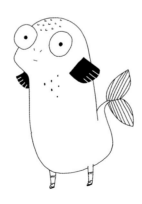
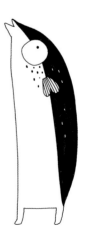

DRAW A MAINE COON

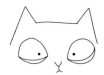

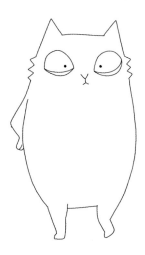

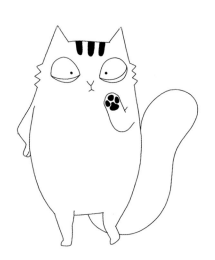

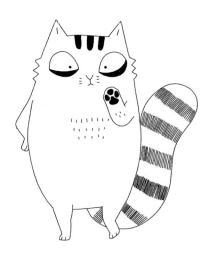

DRAW A BABY WITCH

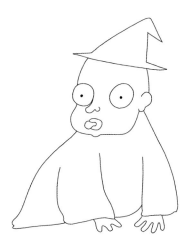

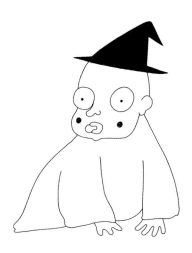

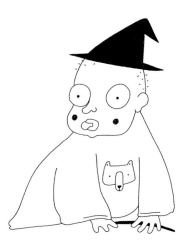

About the Author

Heegyum Kim is a graphic designer and illustrator. She holds a master of science in communication design from Pratt Institute and is the author of two illustrated books featuring Mr. Fox, the charming and humorous character whose activities and musings drive her popular Instagram account and make her followers giggle, as do a menagerie of other delightful animal friends. She is also the author and illustrator behind several titles published by Quarry Books: *Drawing Class: Animals,* which presents step-by-step illustrated instruction for 60 whimsical animals along with video tutorials accessible via QR codes; and the Draw 62 . . . and Make Them Cute series, which provides step-by-step illustrations for drawing different types of cute characters. Heegyum also received honors recognition at the Society of Children's Book Writers and Illustrators (SCBWI) 2022 Winter Conference Portfolio Showcase. She lives in New City, New York. See more of Heegyum's work on her website (mrfox.nyc) and follow her drawing adventures on Instagram (@hee_cookingdiary).

Quarto.com
© 2024 Quarto Publishing Group USA Inc.
Illustrations © 2019 Heegyum Kim

First Published in 2024 by Quarry Books,
an imprint of The Quarto Group,
100 Cummings Center, Suite 265-D,
Beverly, MA 01915, USA.
T (978) 282-9590 F (978) 283-2742

Quarry Books titles are also available at discount for retail, wholesale, promotional, and bulk purchase.

For details, contact the Special Sales Manager by email at specialsales@quarto.com or by mail at The Quarto Group, Attn: Special Sales Manager, 100 Cummings Center, Suite 265-D, Beverly, MA 01915, USA.

10 9 8 7 6 5 4 3 2 1

ISBN: 978-0-7603-9236-2

Digital edition published in 2024
eISBN: 978-0-76039-237-9

The content in this book previously appeared in *Draw 62 Animals and Make them Cute* and *Draw 62 Magical Creatures and Make them Cute* both published by Quarry Books in 2019 and written and illustrated by Heegyum Kim.

Library of Congress Cataloging-in-Publication Data available

Design: Evelin Kasikov
Illustration: Heegyum Kim

Printed in China